LEARN TO DRAW

STAR WARS

™

THE FORCE AWAKENS

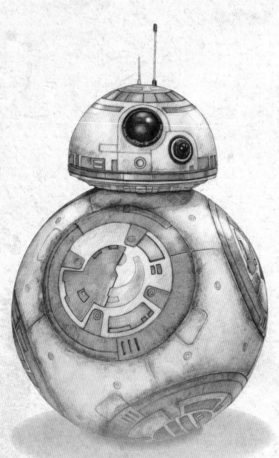

Walter Foster

Step-by-step artwork and text by Russell Walks.
Photographs and text on pages 4–5 © Elizabeth Gilbert,
pages 6-7 © Jacob Glaser, and page 7 (bottom images) © Nolon Stacey.

Published by Walter Foster Publishing,
an imprint of The Quarto Group
6 Orchard Road, Suite 100, Lake Forest, CA 92630

Printed in China
1 3 5 7 9 10 8 6 4 2

FSC
www.fsc.org

MIX
Paper from
responsible sources
FSC® C017606

TABLE of CONTENTS

Graphite pencil is a great starting point for a beginning artist. All you really need are a few basic tools, including the right paper and a few different types of pencils.

Drawing Paper

Paper can vary in weight (thickness), tone (surface color), and texture. Start out with smooth, plain white paper so you can easily see and control your strokes. Also, use a piece of paper as a barrier between your hand and your drawing. This prevents you from smudging your drawing and keeps oils from your skin from damaging the art.

Pencils

Graphite pencils are labeled with numbers and letters—and the combination of the two indicates the softness of the graphite. B pencils, for example, are soft and produce dark, heavy strokes, whereas H pencils are harder and create thin, light lines. An HB pencil is somewhere in between the two, which makes it a good, versatile tool for most artists. For the projects in this book, begin with a basic #2 pencil and a 4H pencil.

Holding a Pencil

There are two common ways to hold a pencil: the underhand position (A) and the writing position (B). The underhand position is great for loose sketches, shading, and broad strokes, whereas the writing position is ideal for detail work.

A

B

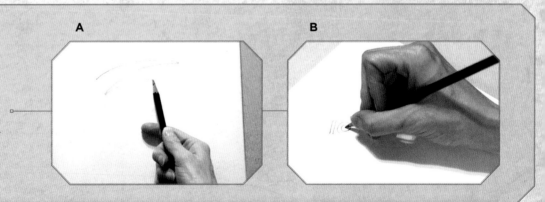

Erasers

Erasers remove mistakes, but they are also effective drawing tools in themselves. You can use them to pull out light lines, add crisp highlights, subtly lighten areas of tone, and more. **Vinyl and plastic erasers** are usually white with a plastic feel. They leave behind a clean surface and are gentle on the paper's fibers. **Kneaded erasers** (usually gray) are pliable like clay, allowing you to form them into any shape. Knead and work the eraser until it softens; then dab or roll it over areas to slowly and deliberately lighten the tone. To "clean" it, simply knead it. The eraser will eventually take in too much graphite and need to be replaced.

Pencil Sharpener or Sandpaper Block

Sharpening instruments give you control over your pencil tips, which in turn gives you control over the quality of your lines. **Handheld sharpeners** shave pencil ends into cone shapes, exposing the lead and creating sharp tips. A **sandpaper block** is essentially a few sandpaper sheets stapled to a soft block with a handle. Holding the block in place, stroke and roll the pencil tip over the surface to sharpen.

Additional Materials

- Gesso
- Paintbrush
- Masking tape
- Straight edge (for drawing straight lines)
- Compass (for drawing circles)
- Reading glasses with a powerful correction or a desk lamp with a built-in magnifying lens

BASIC PENCIL TECHNIQUES

With just a few basic shading techniques, you can render everything from a smooth complexion to a simple background. Shade evenly in a back-and-forth motion over the same area, varying the spot where the pencil point changes direction. Don't shade with a mechanical side-to-side direction, with each stroke ending below the last, as this can create unwanted bands of tone throughout the shaded area.

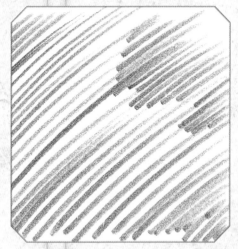

Hatching Make many parallel strokes close together.

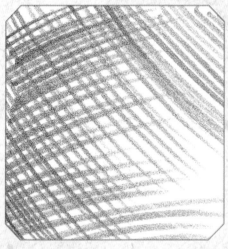

Crosshatching Add another layer of hatching at an angle.

Gradating Apply heavy pressure with the side of your pencil, and then gradually lessen the pressure as you stroke to create a transition from light to dark.

Shading Darkly By applying heavy pressure to the pencil, you can create dark, linear areas of shading.

Shading with Texture For a mottled texture, use the side of the pencil tip to apply small, uneven strokes.

Blending Smooth out transitions between strokes and create a dark, solid tone by gently rubbing the lines with a blending stump or tissue.

TEXTURES

A texture should be rendered based on how the light source affects it. Don't confuse texture with pattern, which is the tone or coloration of the material. Use texture to build a shadow area and give the larger shape its proper weight and form in space. Think of texture as a series of forms (or lack thereof) on a surface. When using this book, you will draw a few different textures, including cloth, hair, and metal.

Long Hair Long hair has a direction and a flow to its texture. Its patterns depend on the weight of the strands. Long hair gathers into smaller forms—simply treat each form as its own sub-form that is part of the larger form.

Metal Polished metal is a mirrored surface and reflects a distorted image of whatever is around it. Metal can range from dull to incredibly sharp and mirror-like. The shapes reflected will be abstract with hard edges, and the reflected light will be very bright.

Cloth The texture of cloth will depend on the thickness and stiffness of the material. Thinner materials will have more wrinkles that bunch and conform to shapes more.

Step 1 Long, straight hair doesn't necessarily lay in perfectly parallel lines. In fact, the longer the hair, the more haphazard it's likely to be. With this in mind, draw long sections of hair, stroking in different directions and overlapping strokes.

Step 2 Carefully shade the dark areas among the hairs, and apply long, light strokes on top of the sections of hair. Then use tack adhesive to lift out some individual hairs, giving depth to the hair.

BB-8

ASTROMECH DROID SERVING THE RESISTANCE

The loyal astromech droid BB-8 accompanied Poe Dameron on many missions for the Resistance, helping keep his X-wing in working order. When Poe's mission to Jakku ended with his capture by the First Order, BB-8 fled into the desert and was rescued by a scavenger named Rey. In silhouette, BB-8 looks just like his name—like two back-to-back uppercase B's, or a number 8. He's easy and fun to draw, especially if you have a compass to help you draw perfect circles.

Start with a shape that looks almost like an 8—a large circle with a smaller circle sitting on top of it. The center of the upper circle (which is half the size of the bottom circle) is just slightly above the bottom circle. Use a compass to draw these, and later, once the basic lines are established, just "eyeball" it.

STEP
TWO

Begin adding detail. Use a compass for the photoreceptor and main tool bay. Because the tool bay isn't centered in the bottom circle, adjust by hand to make it look slightly distorted. The bottom circle needs to look like a sphere. Achieve this look while shading and by carefully curving the outlines of each tool bay.

Add more detail, drawing lightly and relatively loosely. The circular panels of his body are all different, so keep that—and perspective—in mind while adding detail.

STEP
FOUR

Keep refining the details here. It can be intimidating to draw all of these elements accurately, but keep in mind that BB-8 also has some weathering, and that you can add a little dirt later on to hide some shakiness or inaccuracy.

Erase any extra initial guidelines and begin shading from top left to bottom right (work opposite if you're left-handed). This will keep you from smudging your drawing.

Although BB-8 is white, don't let that influence your shading. First, he's dirty, and second, you need to take shadow into account. Finish shading the dome. Use these values as a key for shading the rest of the drawing.

The only places on the finished drawing without shading will be in the highlights: the center of his photoreceptor, and in reflections on the top of his dome.

STEP
SEVEN

On the bottom sphere, start with an even, unidirectional pencil stroke to lay down a light gray base tone. Don't worry about staying in the lines; use a kneaded eraser to wipe away the excess pencil and emphasize the highlights.

STEP
EIGHT

Begin shading the bottom
sphere, and work from the top
left to bottom right. To avoid
smearing the graphite you're
laying down, work with a sheet
of blank paper under your hand.

STEP
NINE

Shade the rest of the sphere. The bottom is the darkest area. Even if your highlights are evident and there is some dimensionality in the image, spend some time during the final polish pushing these elements even further.

STEP TEN

Go through the entire drawing again to add value and contrast. Pay attention to the surface detail and texture, as well as the appearance of shadow and light. After this, BB-8 should really look like a three-dimensional sphere that could roll right off the paper!

POE DAMERON

RESISTANCE PILOT COMMANDER

Poe Dameron is the commander of the Resistance Starfighter Corps' Black Squadron and one of General Leia Organa's most trusted operatives. The son of a rebel fighter pilot and a rebel commander, Poe grew up to become a decorated pilot who could fly any kind of ship. To emphasize Poe Dameron's heroism, he is depicted from below eye level so that the viewer is looking up at him.

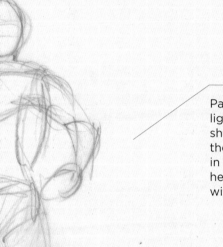

Paying attention to your reference, lightly sketch out Poe's general shape. The viewer is looking up at the figure, so while perspective is in play, keep in mind that Poe is a hero, and heroes are often depicted with slightly larger heads.

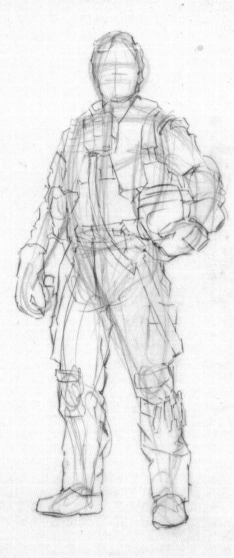

STEP
TWO

Locate where the eyes, mouth, and nose will go, but don't worry yet about defining them. Also locate the vest, life support box, exhaust hose, helmet, belt, gloves, pockets, and other details on his flight suit.

STEP
THREE

Start tightening things up, adding details. Concentrate on the face and the life support box and hose. Be particularly careful with the face. You not only want to get the likeness accurate, you also want to capture the essence of one of the Resistance's greatest heroes.

Erase any extraneous lines, and draw new lines lightly. To help with shading, which you'll begin in the next step, do your best to outline all the shapes you see in your reference, even if it is in shadow. When doing this, use four different values (white, black, light gray, and dark gray), keeping in mind that you'll be adding value later.

STEP
FIVE

Start adding value, concerning yourself primarily with the gray tone of his coveralls, which are orange when seen in full color. Get as close to a medium gray as you can so the suit will contrast nicely with the white vest and the black gloves and boots.

RESISTANCE

STEP SIX

Shade the belt and begin on the pants by laying down a light gray base tone. The helmet is a hard, shiny surface that contrasts texturally with Poe's clothing, so minimize any evidence of linework. You can go back to the helmet during the final polish, so don't worry if you're not 100 percent happy with it now.

STEP
SEVEN

Add value to the rest of the coveralls. Although Poe's belt visually breaks his uniform in half, it's important that the values on the top and bottom halves match.

RESISTANCE

For the final polish, begin at the top and work your way down, tightening areas, adding contrast, and clarifying. Spend extra time on the helmet to make sure it contrasts nicely with the uniform. You can do a little more blending on the face and add some sparkle to Poe's eyes with a small drop of gesso.

FIRST ORDER

KYLO REN
FIRST ORDER COMMANDER

A dark warrior strong with the Force, Kylo Ren commands First Order missions with a temper as fiery as his unconventional lightsaber. While apprenticing under Luke Skywalker, Kylo chose the dark side and decided to follow in his grandfather Darth Vader's footsteps instead. Now a leader of the First Order and student of Supreme Leader Snoke, Kylo seeks to destroy the New Republic, the Resistance, and the legacy of the Jedi.

Start by sketching a dramatic pose: Kylo with his body tense and his feet well apart, sweeping his unique lightsaber from left to right.

While roughing out Kylo's clothing, increase the size of his upper arms. The clothing should demonstrate his movement.

STEP THREE

Tighten and begin to finalize your outline, and erase some parts of the body that won't be visible under the drawing.

STEP FOUR

Complete the underdrawing in this step by outlining all the areas of light and shadow using the four basic values (black, white, light gray, and dark gray). Kylo wears arm-wrappings, and although you should pay attention to the spacing of the lines when drawing them, it's not an exact science.

FIVE

Begin the shading process. Remember that while we say Kylo's costume is black, that's not necessarily what we actually see. What we see is a cloak that is black where it's shadowed, but an almost light gray where the light reflects from it. The only truly black area is the darkness under his hood, and the only truly white areas are the reflections off the chrome in his mask.

STEP SIX

For Kylo's arm-wrappings, use a series of one-directional pencil strokes running perpendicular to the horizontal bands stretched across his arms. After completing the entire arm, use a 4H pencil to smooth things out a bit, and then go back to a softer #2 to add shadow. Shade the belt using only the #2 and some even, smooth, one-directional pencil strokes.

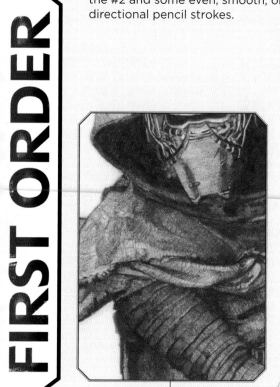

There are three distinct textures in Kylo Ren's clothing: the rough-hewn, almost burlap material from which his outer cloak is made; the lighter, tightly woven material that makes up his robe; and the smooth, slightly reflective fabric making up his pants and arm-wrappings. Emphasize the coarseness of the cloak by using strong horizontal pencil strokes and occasional crosshatching.

Shade the outside cloak using the technique mentioned in step five, but because Kylo's inner robes are different material, shade them in a much smoother manner—basically the same way as the belt and mask. Your goal is simply to indicate that the inner robes and outer cloak are two different materials, not to perfectly duplicate your reference.

STEP
EIGHT

To portray the glow of Kylo's jagged, splitting lightsaber, leave the core white, and shade right up to the edge. Then roll out and flatten a kneaded eraser, making it just a little longer and wider than the saber's core. Carefully press it onto the paper, allowing it pick up just enough graphite so that lightsaber looks like it's glowing.

FIRST ORDER

STEP
NINE

During the final stage, emphasize the roughness of Kylo's outer cloak, strengthening the contrast between it and his inner robe. If needed, slightly darken the hood and scarf. Go back to the lightsaber, dabbing at various spots with the kneaded eraser, to show the blade's instability, which adds to the feeling that Kylo is struggling with the light side within himself.

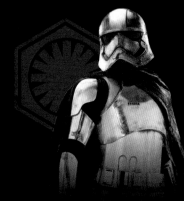

CAPTAIN PHASMA

FIRST ORDER CAPTAIN

Clad in distinctive armor of salvaged chromium, Captain Phasma commands the First Order's legions of stormtroopers. A tough veteran commander, Phasma rules her subordinates with an iron fist, and it's easy to imagine a terrified stormtrooper seeing his own fear reflected back at him in Phasma's armor. While chrome may seem daunting to draw at first, it's not too difficult as long as you keep in mind where the light is coming from.

In your initial sketch, nail down Phasma's proportions. Her torso is longer than one might expect, which makes her arms and legs appear just a little short. Phasma's armor doesn't entirely hide her gender—you can see that her hips and upper thighs are slightly wider than a typical man's would be.

Start to define the armor, and add the beginnings of the Captain's cloak, the traditional cape of First Order command.

STEP THREE

Keep tightening things up and add more detail. The most detail is located on Phasma's midsection and hands.

STEP FOUR

Indicate all the reflections on her armor and shadows on her cloak by outlining what you see on your reference. Use four basic values (black, dark gray, light gray, and white), which will help you during the shading process.

Start shading the helmet and begin to work on the cape. Use the darkest black on the areas in deepest shadow. For the majority of this drawing, you will use a soft #2 pencil, but you'll occasionally break out a 4H.

Work from top to bottom and left to right so that your hand rarely rests on values you've already laid down (again, work right to left if you're left-handed). As you shade, make sure the dirty chrome contrasts nicely against the texture of Phasma's cape.

STEP SEVEN

It is always helpful to know how light reflects off the substance you are drawing. Generally, a chrome cylinder reflects light in this way: light gray next to white, which, in turn, is next to black or dark gray. Then the light gray repeats. This is how the shading should look on Phasma's calf pieces.

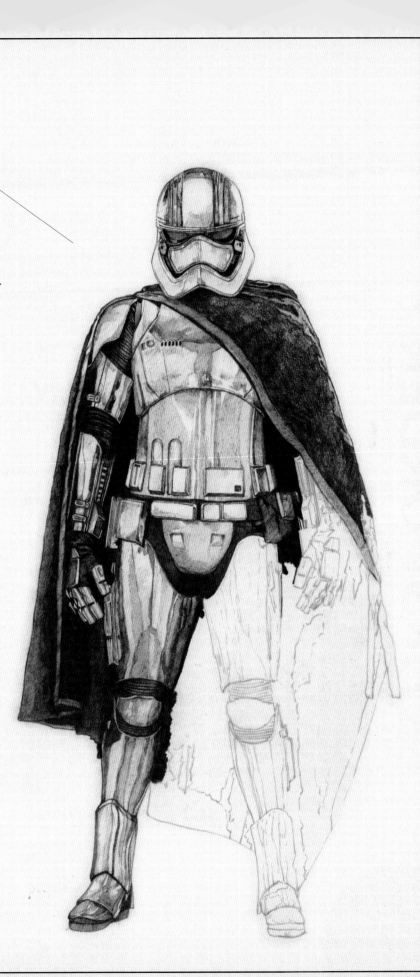

While chrome can seem imposing to draw, it's fairly forgiving if one keeps in mind where the reflected light is coming from. Because Phasma's armor is slightly dirty and battle-worn, adding a little dirt and grit can easily help hide a few mistakes with regard to reflection.

To create the cape's texture, vary the stroke direction and length, then dab the surface with a crumpled, wrinkly kneaded eraser. Then go over the surface once more in one direction, softening the stokes and textures slightly.

FIRST ORDER

STEP
NINE

Finish up the final polish with a dull 4H pencil, blending and softening any harsh edges. Hopefully you and Captain Phasma are happy with the finished work—it's not a good idea to disappoint her!

FINN

FORMER FIRST ORDER STORMTROOPER FN-2187

Finn spent most of his life as FN-2187, a stormtrooper serving the First Order. However, his first battle, on Jakku, awakened his conscience and drove him down a different path, one that proved both heroic and dangerous. He helped Poe Dameron escape the First Order—picking up the nickname Finn in doing so. He then sought his own freedom alongside Rey and BB-8. Much like Han Solo, Finn joins the Resistance as a means to an end, but ends up a hero, willing to sacrifice himself to save the ones he cares about.

STEP
ONE

Start with a loose sketch to outline Finn's pose. Finn is well-muscled, particularly around his core and upper thighs, so be particularly accurate in this area, even at this early stage.

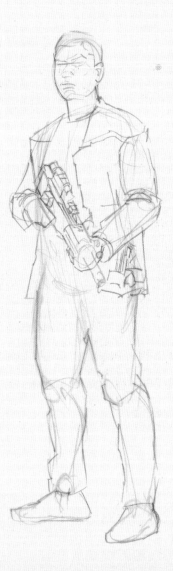

STEP
TWO

Add clothing and details, and begin to rough out the complicated weapon he is holding. Also locate his facial features and hairline.

STEP
THREE

Work on nailing down the
details in Finn's jacket and gun.
Remember to outline value and
depict what you see as opposed
to what you *think* you see.

STEP
FOUR

Complete the underdrawing,
doing your best to indicate each
of the various values you see in
your reference. While his right leg
is in shadow, there's a lot of light
hitting Finn's left leg; this means
more detail.

STEP
FIVE

Begin shading at the top of the image with Finn's hair. There are a lot of strong shadows on his face, which help define his facial structure and help you get an accurate likeness. After finishing his face and neck, shade his shirt, stopping at the blaster.

STEP SIX

Begin adding value to Finn's arm and hands, then move to the incredibly complicated blaster. You'll probably spend quite a bit of time on it.

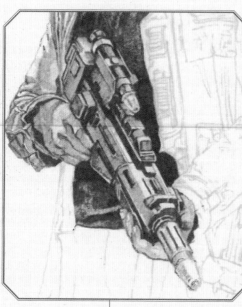

This drawing is realistic enough that most of the detail should be depicted, although details in some of the shadowy areas can simply be suggested. The most important thing to keep in mind when drawing machinery like blasters and spaceships is that parallel lines need to stay parallel.

STEP SEVEN

The jacket (which is really Poe Dameron's) has a light, satiny shine to it. To depict this, use a smooth, one-directional pencil stroke, being careful to leave the highlights white. Note that Finn is carrying Luke's lightsaber here—it's peeking out just below his left forearm.

STEP EIGHT

Work on the lower half of Finn's body, making sure there is enough contrast between the blaster's hanging shoulder strap and Finn's right leg, which is in dark shadow.

STEP NINE

Soften the angles and smooth out any hard lines on Finn's face, and adjust the eyebrows. Then go through the entire drawing, deepening shadows and contrast, while lessening the obviousness of the pencil strokes.

REY

FORCE-SENSITIVE JAKKU SCAVENGER

Rey is a scavenger, a survivor toughened by life on the harsh desert planet of Jakku. When the Resistance droid BB-8 appeals to her for help, Rey finds herself drawn into a galaxy-spanning conflict. It's important when depicting Rey to capture her innocence and essential goodness, but also her and courage— something she constantly displays, even though she's not yet a confident warrior. If you can establish those traits as well as an accurate likeness, your finished work will not only look like Rey, it will carry some of her spirit, as well.

In the initial sketch, suggest the drama of Rey's pose, while remembering her femininity. Rey is toned but not muscular.

Flesh out the details. Work out the gauzy drapery, and adjust the head and hand size. Traditionally, heroes are depicted with slightly larger heads and hands, so make Rey's just a tiny bit bigger than normal.

STEP
THREE

Tighten the details, and erase the most obtrusive areas of your initial underdrawing. You may need to use a magnifying glass as you define the planes and features of Rey's face. It's essential that these are accurate for an effective likeness.

Finish the underdrawing, indicating the details of Rey's clothing as well as the areas of light and dark that you see in your reference. Define the shadows and light with four basic values (black, white, and two shades of gray in between), which you will blend together in the shading process.

STEP FIVE

Normally, you would start at the top left and work down and to the right. This helps to keep from smudging your drawing. But for this drawing, save Rey's lightsaber until the end. Start with her hands, lightsaber hilt, and face, using a magnifying glass.

Rey's arm-wraps are translucent and require a light touch. Draw each band individually, and use a sharp pencil to add texture and details. Don't worry about shading at first. Once you've completed the details, add shadow over the entire area. Shade Rey's shirt with a very light gray, knowing that you can go back and accentuate the highlights with a kneaded eraser.

STEP
SEVEN

Move on to Rey's gauzy drapery. Don't worry about duplicating each of the wrinkles and creases in her clothing. You simply want the effect; there's no need to draw every single one. Also draw Rey's bag, which has a ribbed texture along the sides. Emphasize this by making some horizontal strokes with a 4H pencil.

STEP
EIGHT

To create the lightsaber glow, use a #2 pencil and go around the saber blade with short, one-directional strokes. Follow with a 4H, using slightly longer, lighter strokes. Then finish shading Rey's bottom half. Keep in mind that her boots aren't leather; they're made of Govath wool, which is fuzzy and non-reflective.

STEP NINE

During the final polish, soften harsh edges or inappropriate linework, particularly around Rey's face. This is your opportunity to correct likeness-related issues. Add a little contrast to the entire drawing. Darken the shadows and smooth the areas where the textures seem a little distracting. Your completed drawing should display the courage, goodness, and potential of this fledgling Jedi.

Add highlights to Rey's eyes with a tiny paintbrush and a touch of gesso. Gesso is a liquid, chalk-based medium used for prepping canvas. It's inexpensive, matte, and you can draw directly on top of it, so if the eyes seem a little too bright after that, tone down the contrast by lightly penciling over the dried gesso with a 4H pencil.

LEIA ORGANA

FOUNDING GENERAL OF THE RESISTANCE

General Leia Organa, leader of the Resistance against the First Order, has been a capable, confident commander for decades. But life under the New Republic has not been easy for Leia. Her brother, Luke Skywalker, is missing, and her son, now called Kylo Ren, has turned to the dark side. Yet, Leia's will remains strong, and she continues to do what she has always done: She leads. Our goal when drawing Leia is to not only capture the confidence and commanding nature of the Resistance's greatest leader, but also the tragedies of her past.

Begin by laying out the general shape of Leia's head and chest and locating the features of the face. At this stage, don't worry about facial features or clothing.

STEP
TWO

Add a little more definition. Locate the hair and begin working on the shape of Leia's nose and eyes. Rough out the composition. At this stage, the plan is to draw Leia's shirt in detail and simply suggest the vest.

STEP
THREE

Add detail to the hair, doing your best to break the shadows and light down into four basic values and outlining them. Luckily, hair is relatively forgiving. Squinting will help you see where the various light and dark areas meet, and if you're able to capture most of what you see in your reference, you've done well.

RESISTANCE

STEP FOUR

The eyes, nose, and lips are extremely important when depicting Leia's personality. The sadness Leia carries is evident in her eyes, while the steadfast commander in her is visible in the lift of her chin and in the firmness of her mouth.

STEP
FIVE

Begin shading the hair. The light is hitting Leia's head from our upper left and is reflecting along the top of her braid. Her hair is darkest in the shadowed area above her ear. While hair can be intimidating, remember that as long as the hair *looks* right—as long as the shadows and light look realistic and accurate—the occasional mistake is OK.

RESISTANCE

STEP SIX

Move to the face. Here her eyes are depicted just a little larger than in real life, which accentuates their expressiveness. As you move down to the nose and mouth, keep in mind the determination expressed in the firmness of Leia's upper lip. When shading Leia's face, keep the pencil strokes moving in the same direction, and use a light touch.

STEP SEVEN

Complete the detail on the shirt. While the original plan was to just suggest the vest, doing so makes the drawing seem incomplete. It might be a good idea to change course and add a little detail and contrast. Always be open to change!

STEP EIGHT

Shading the vest will balance out this portrait. It adds more than just light-dark contrast; it's also an opportunity to show the vest's rough texture, which will make the smoothness and beauty of Leia's face more evident. As a drawing evolves, so does the artist's point of view.

Now add the final polish. Hopefully the finished work captures not only Leia's likeness, but her personality as well. Your goal is to capture emotion, and if the viewer of the finished piece feels this, then your work goes from a simple character study to something almost alive.

HAN SOLO

REBEL LEADER AND SMUGGLER

Our goal in depicting Han Solo as he appears in *The Force Awakens* is, of course, to portray the heroic qualities he's displayed for the last 40 years. More than that, though, we want to indicate that time hasn't left our hero untouched. Han's been through a lot since the events in *Return of the Jedi*, and the weight of time is visible in his face. Our job is to depict the experience and wisdom of an aging scoundrel, while making sure that we don't lose any of the charm and charisma that makes Han Solo the hero we've loved for four decades.

STEP ONE

Start with a loose sketch depicting the underlying anatomy. Lightly indicate the location of Han's major facial features. The eyes should be in the middle of the skull, and the nose and the bottoms of the ears should roughly align. For a nice composition, draw straight lines on the bottom left, bottom, and right, to create a frame for Han's upper body.

STEP TWO

Locate and define more details. Indicate that Han is looking off to the side, as though he's searching for an answer somewhere in the distance. Begin to lay out and define his hair.

STEP
THREE

There is a lot of linework in this drawing, requiring a lot of time and concentration. The key is to use your reference as a guide and to depict values rather than shapes. If you depict the values accurately up front, the shapes will define themselves during the shading process.

RESISTANCE

Han's hair color is gray, but gray hair is really a variety of values from black to white. While you're drawing, always pay attention to what you see, as opposed to what you *think* you see. There's also no real definition between Han's hairline and his forehead, but don't let that concern you. By the time you're finished, it will look fine.

STEP FIVE

Han's jacket looks like worn leather. Have fun playing with the texture and shine. The lightest parts of the jacket are where it's reflecting light, and the darkest parts are in shadow. After completing the values, go back in and add some scratches and a little texture, but remember that the leather was originally smooth.

STEP SIX

Keep shading Han Solo's face. He has a crooked nose and a scar under his bottom lip. It's essential that you depict those elements correctly, or your finished portrait just won't look right. And while Han is unshaven, don't draw every whisker. Just use a sharp #2 pencil and an occasional scribble to indicate stubble.

STEP
SEVEN

Note the way the light is hitting the right side of Han's face (his left) and leave some areas white. Don't outline the edge of his face in areas where it's highlighted. And while it should be evident that Han's been around the galaxy a few times, don't overdo it.

STEP
EIGHT

Finish adding value to the rest of Han's jacket and shirt. Add value sparingly; the shirt's collar should be lightly shaded, but most of the shirt is white and reflects a lot of light. It won't need much shading.

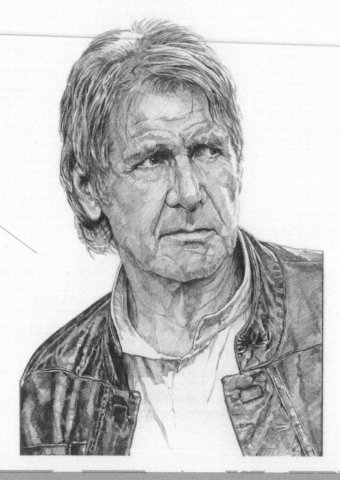

In the final polish, add some
individual hairs. Deepen the
contrast in some areas, and
smooth out some of the wrinkles
in others. The final portrait should
depict Han as both the hero we
know and love, and as a man
who's haunted by his past—by the
mistakes and actions he wishes
he could go back and change.

ADMIRAL
ACKBAR

ADMIRAL COMMANDING THE ALLIANCE FLEET

Admiral Gial Ackbar is a Mon Calamari officer and brilliant tactician who commanded the Rebel fleet in their successful attempt to destroy the second Death Star and defeat Palpatine, ending the Emperor's reign and setting the stage for the New Republic. Thirty years later, Admiral Ackbar once again stands by Leia's side as she forms the Resistance and attempts to suppress the rise of the First Order.

Admiral Ackbar looks like a cross between a fish and a lobster. Visually, he's one of the most interesting characters in the *Star Wars* universe and is exceptionally fun to draw. Start with some basic rounded shapes, locating the eyes on the sides of the head, with the mouth slightly below center.

STEP
TWO

Continue to define your drawing, adding details throughout. The reference for this portrait doesn't completely show Ackbar's hands. If you have an incomplete reference, you can often fill in the blanks with other reference images. But if it's something a bit more difficult, like depicting the unique hands of an alien species, you still have options. With this portrait, add a frame to crop out the mystery area (see step eight).

STEP THREE

Using the four basic values, define the areas of shadow and light that you see in your reference. There are some differences in the Ackbar we see in *Return of the Jedi* and in *The Force Awakens*, principally in his whiskers, which have grown with age. Add everything you see in your reference, except leave his hands unfinished. Erase any obvious lines from the underdrawing.

STEP FOUR

Begin shading from top to bottom. After drawing a lot of human faces, Ackbar's face is a fun change. Define the areas of light and dark with some light shading, then begin mottling his skin with soft #2 and 4H pencils, keeping in mind that the darkest areas on his face are in his eyes and the depths of his mouth.

STEP
FIVE

As you work on the lower part of his face, concentrate on defining the areas around his whiskers, along with the ridged areas on his neck. These ridges are hard, like a lobster's shell. They should have well-defined edges and a distinct, satiny shine.

Ackbar's vest is soft and felt-like. To define its value, use a soft #2 pencil. Then sharpen it and add some one-directional horizontal texture.

STEP SEVEN

Think "lobster" as you draw Ackbar's hands and forearms. They are hard and shiny. The sleeves and tunic are simpler to depict but require a light pencil stroke.

STEP EIGHT

Because the hands are cut off, this drawing needs something like a textured frame to look complete. Using a straight edge, draw a rectangle to enclose Ackbar, but leave his head and elbows popping out of the frame. Shade the frame, with a lighter value at the top blending into a deep, velvety black at the bottom.

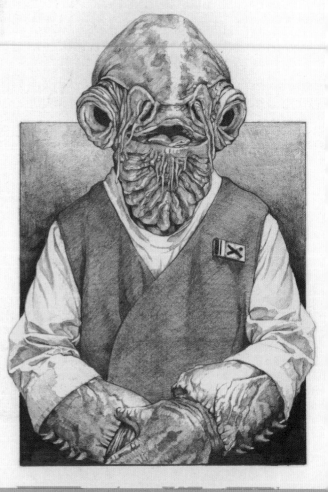

STEP
NINE

Now that you have a frame that gives the drawing more visual interest and completes the composition, add a final polish. Soften any particularly harsh edges, add a little detail, and emphasize the shine on his lobster- and squid-like arms and head.

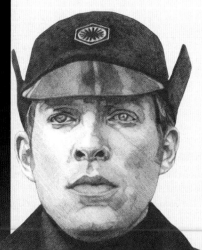

GENERAL HUX

GENERAL OF THE FIRST ORDER

A ruthless young officer in the First Order, General Hux has complete confidence in his troops, training methods, and weapons. He hates the Resistance with every fiber of his being, and when he talks (or shouts) about the glory of the First Order, the light in his eyes indicates his passionate, all-consuming love for the regime to which he's dedicated his life.

In this piece, Hux is depicted from the point of view of a First Order stormtrooper looking up at him as he holds a rally on Starkiller Base. The initial sketch is almost symmetrical. Because the viewer is looking up at him, the perspective of the face's anatomy changes slightly. The nose will be in line with the centers of the ears, not with the bottoms.

STEP
TWO

Add some definition to the initial sketch and begin to think about composition. Only the center of Hux is defined, with his collar and belt buckle as the outside edges of the frame in which he'll be enclosed. This can be changed later on, if needed.

STEP THREE

Complete the underdrawing, outlining the areas of light and dark visible in the reference. Hux has pale, smooth skin and is dressed in all black, so he won't have nearly as many lines as Han Solo's underdrawing, for example.

STEP FOUR

Hux's cap is made of several different materials, so make sure the contrast between the cap and bill is evident. For the cap, use a soft, loose pencil stroke, allowing the "tooth" of the paper help determine the texture. For the bill, sharpen your pencil and use a tighter one-directional stroke.

STEP
FIVE

Begin to define the values in the face. Hux's eyes shine, making him appear zealous and near-insane. To show this, simply draw the pupils smaller than normal, while leaving the irises lighter than they would normally appear.

STEP SIX

Finish Hux's face. Note that it's slightly darker and more shadowed on the right. To add a little texture to the face, use a slightly firmer stroke with a slightly sharper pencil than usual. This should make the face contrast with the texture of the trench coat, which is made of a soft wool.

STEP SEVEN

Work on the coat with the same technique you used on the cap: Use a soft 4H pencil with a light stroke. The coat takes some time because you are laying values on top of one another to eventually reach the darkness you're looking for. To add a little contrast between the coat and uniform top, use horizontal strokes to define the texture of Hux's tunic.

Move from left to right, keeping in mind that the right side is more deeply shadowed. You could stop here, but if you don't like the composition, you can change it. You can keep going by adding Hux's shoulders and arms.

STEP NINE

Begin by loosely framing a rectangle from which Hux's shoulders will protrude.

STEP TEN

Shade the shoulders and arms, achieving the same texture you created on the coat's lapels. Note the "stair step" effect caused by the three levels of coat, collar, and buckle.

STEP ELEVEN

In the final polish, increase the contrast, while emphasizing the texture in Hux's coat and tunic. Also add some contrast to those fanatical eyes.

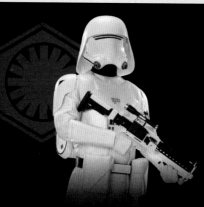

SNOWTROOPER

FIRST ORDER SOLDIER

First Order stormtroopers assigned to frigid planets such as Starkiller Base wear specialized armor and gear that let them operate effectively in icy conditions. To keep warm, they wear gloves, a kama, and a heat-resistant body glove beneath an oversuit of wind-resistant fabric. Armored First Order snowtroopers not only look really cool, they're fun to draw. Seeing so much non-reflective, matte white might lead you to believe that it would be difficult to create contrast and interest, but, luckily, that's not the case.

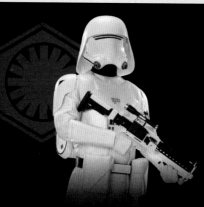

FIRST ORDER

Start with a loose initial sketch. Use a small amount of foreshortening on his right leg and foot. This may make the anatomy look a little off, but this will resolve itself as you work.

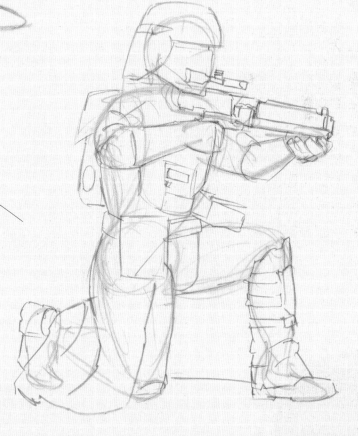

STEP
TWO

Refine and add detail, including the kama (cape), which is draped over the snowtrooper's right leg. Also place the pack and helmet.

STEP
THREE

Tighten the drawing and erase some of the nonessential linework. The upper right arm is foreshortened, so put a little extra effort into defining and clarifying the elbow joint.

STEP
FOUR

Outline the various values you see in your reference. The snowtrooper's armor is mostly matte, so there are more subtle differences in value than in the standard stormtrooper armor, which is shiny. The linework will be a little softer than usual, particularly on the cape and legs.

STEP FIVE

Start shading at the top left and work down toward the right. Do your best to keep your pencil strokes moving in the same direction. Build these subtle values slowly by layering your strokes on top of one another.

STEP
SIX

Define the blaster here, noting that the scope caps are brushed metal. Shade them differently than the blaster stock, using sharper lines with more definition between values.

STEP
SEVEN

Remember that while something may
be white, it will only appear white where
the light is hitting it directly (at the
top of this stormtrooper's helmet, for
instance). So the key is to think about
what value the armor reflects, not what
value the armor is.

STEP
EIGHT

As you finish up the front leg and the bottom of the cape, concentrate on using some linework to define different areas. Inside those areas, define by value. For instance, there's very little linework in the cape. Most of the definition is created by changes in value. This is the reason for using soft, subtle lines in the initial drawing.

STEP
NINE

Blend using a 4H pencil in this final step,
softening transitions and minimizing
the evidence of pencil strokes, and your
snowtrooper is complete!

TIE FIGHTER

FIRST ORDER STARFIGHTER SHIP

The TIE/FO fighter is the primary frontline attack vessel used by the First Order. Although it's similar in appearance to the Imperial TIEs used against the Rebellion during the reign of Palpatine, the deadlier new fighter has improved solar cells, higher capacity converters, and deflector shields. TIE fighters are relatively simple to depict, as long as you bring a few things with you to the drawing table: a basic knowledge of perspective, a straight-edge, a compass, and a willingness to re-draw areas that don't look right.

Draw a loose initial sketch. Pay close attention to perspective: The forward edges of the wings should look a little taller than the aft edges. If you were to draw lines from left to right across the top and bottom of the wings, they would be parallel.

Tighten up the initial sketch using a straight-edge to define the basic outline and a compass to indicate the shape of the fuselage and cockpit window.

STEP THREE

Concentrating on the fuselage, add more details. Define the shadows and light by outlining with four basic values. While a TIE fighter is symmetrical, the symmetry is only really visible if the lighting is even. This TIE is lit from the upper left, so draw what you see in your reference, not what you think you should see.

STEP FOUR

Add detail to the wings. Again, break down the image into approximately four values and outline each of them.

STEP FIVE

Before you begin shading, add some light definition to the solar panels on the wings.

STEP SIX

Begin adding values. In bright light, the solar panels would be white, but because there are some shadows evident, lightly shade the left panel with a 4H pencil and build up an even gray tone.

STEP SEVEN

The fuselage is gunmetal gray, except where light is reflecting directly off of it. Then it appears lighter—almost white.

For the cockpit windows, don't draw the details of what's behind the glass, but don't shade everything completely black, either. Instead, suggest details. To do this, darken the cockpit windows—except for the upper-left reflection—and then lightly dab at them with a kneaded eraser that's rolled to a point. This makes it look like something is behind the glass without having to define what that something is.

STEP
NINE

Shade the wing on the right. The light is coming from the upper left, so the right solar panels will be a bit lighter than the ones on the left.

STEP TEN

During the final polish, darken the areas in deepest shadow and smooth some of the more obvious pencil strokes. Finally, check for parallelism between the wings. You want your finished TIE fighter to look like it can fly straight off the paper and into the viewer's face, not in a looping circle right back into the desk!

T-70
X-WING

SIGNATURE COMBAT CRAFT OF THE RESISTANCE

The Incom T-70 X-wing is the latest incarnation of a classic design. This powerful weapon against the First Order is expensive, so the credit-strapped Resistance keeps X-wings in commission for a long time. Over time, each spacecraft acquires many battle scars and is customized by its pilot. Because each one is different, the artist can customize the drawing, and as long as the rules of perspective and symmetry are obeyed, the finished project will display both the look of a dynamic starfighter and the personality of the artist who drew it.

STEP
ONE

Loosely sketch the X-wing. It is basically a squat "X" with an octagon in the center and half-circles on either side. If the ship were heading directly toward the viewer, it would look entirely symmetrical, but it would also lack dimension, so it is shown here at a slight angle.

STEP TWO

Use a straight-edge to define the hard lines and a compass to depict the engine outlines. Using tools in this early stage will help the finished product look accurate.

RESISTANCE

STEP
THREE

Add more detail and outline the value changes. The underdrawing is now complete, and the drawing is ready for shading.

STEP FOUR

Moving from left to right, work on the left side of the "X," saving your darkest blacks for the shadowy area inside the engines.

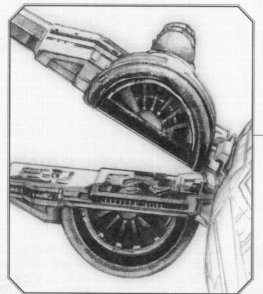

The bottom wing is shadowed by the upper wing, so simply suggest the detail here, rather than including as much detail as the upper wing.

STEP FIVE

When shading the fuselage, add racing stripes, blaster burns, and lots of dirt. The cockpit is black, but add a slight reflection on the upper right and a slightly darker shadow on the right side.

STEP SIX

Complete the wings on the right. They are similar to the left, just in slightly more shadow. If there are a few areas that could stand some more detail, handle those during the final polish.

STEP SEVEN

Moving from the upper left to the lower right, add detail and smoothness. Deepen the shadows on the engines and lower right wing, and define the paint on the wings to display the pilot's personality and the history of this particular spacecraft.

R2-D2

ASTROMECH DROID

The brave and resourceful astromech droid R2-D2 is also a skilled starship mechanic and fighter pilot's assistant. Pretty good for a droid that doesn't communicate in the standard Basic language, or Huttese, or even Ewok. In fact, Artoo doesn't even have a mouth...or eyes or hair. Basically, he is a cylinder topped with a half-sphere. The key to depicting R2-D2 is capturing some of personality and character he's developed over the years he's spent wandering the galaxy, saving his friends.

STEP ONE

The initial sketch is simply a square with an almost half-circle on top. Couple those two shapes with some skinny rectangles and opposing parallelograms, and you have Artoo's basic outline.

STEP TWO

Begin adding detail, working from the top down. Use a ruler or anything with a straight edge for this. While it's not necessary for the circles to be perfect, there are templates available online or and at your local art store to help you.

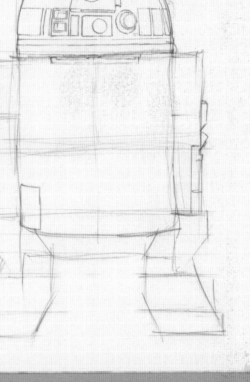

Keep adding detail. Because R2-D2's body is a cylinder, there is a gradual curve to the horizontal lines, so use a straight edge for the vertical lines only. If you used a straight edge on all the lines, Artoo's shape would flatten, and the three-dimensional effect would be ruined.

RESISTANCE

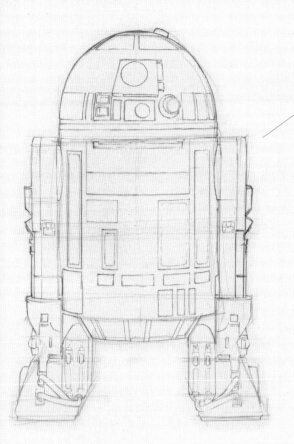

Complete the rest of the basic linework on the legs and feet.

STEP
FIVE

Complete the details on Artoo's front panel, erase the majority of the guidelines, and clearly define the outside edges of the drawing. If you were to finish by simply darkening things up, you'd have a nice line drawing.

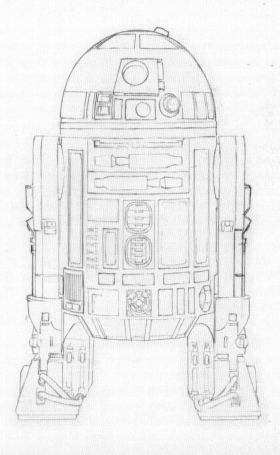

STEP SIX

Define the values that you will be shading. Attempt to break the reference image into four basic values: black, white, dark gray, and light gray. Then outline those values here, which you will blend when you shade.

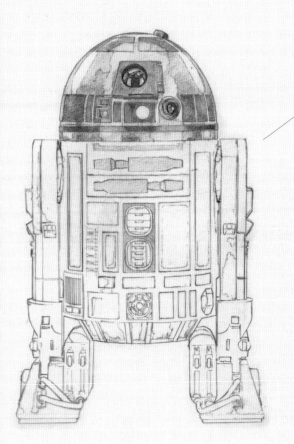

Begin shading and work from the upper left to lower right. Artoo's dome is only slightly reflective, like brushed aluminum, so values should be blended together a little more subtly than with a shinier surface. There is a little grit visible on the drawing at this point; some residue from the early guidelines and some light scribbling. Leave these here: The R2-D2 depicted in this drawing is far from pristine.

STEP
EIGHT

Keep shading. Although R2-D2 was originally white, his surface is now dirty and weathered, so lightly cover almost everything with pencil, leaving only the highlights untouched.

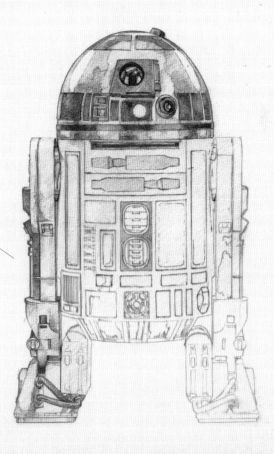

STEP
NINE

Finish shading the rest of R2-D2
from left to right, top to bottom.
He's almost complete, but he needs
a final polish.

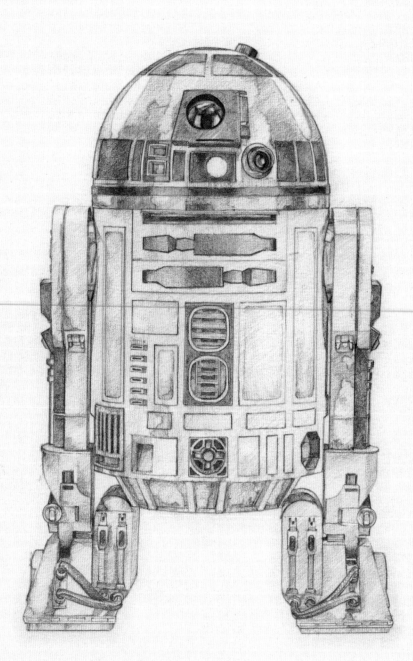

STEP TEN

Increase the contrast a bit, accentuate some of the dirt evident on the surface, and lightly dab a kneaded eraser around the light-emitting lens on Artoo's dome. The glowing light indicates he's activated. Maybe if we ask him nicely, he'll tell us where to find Luke.

LUKE SKYWALKER

JEDI MASTER

The idealistic young Jedi who destroyed the Death Star and ended the reign of Emperor Palpatine is gone, left somewhere in the past with the memories of a dream that's died. Who Luke Skywalker is now is a mystery. Our goal in depicting this version of Luke is to capture not just his likeness but also the sadness evident in his eyes—the sadness of a Jedi who's seen the darkness slowly overwhelm the light.

STEP
ONE

In the initial sketch, locate the major features of the face, ignoring, for now, the fact the Luke has a beard. Most often, the eyes are located in the center of the skull. It's a common mistake to place them higher than that.

STEP
#

Rough out the hair and beard here, and begin work on Luke's nose, which is asymmetrical.

THREE

Define and detail the values throughout the drawing, paying close attention to the hair and beard. Don't try to duplicate the hair exactly. It's more important to capture the direction of the light and the way that the hair is broken into segments by the wind.

RESISTANCE

STEP FOUR

Luke's bulky robes make him look overly broad. Think about the composition of your portrait; if you frame the bottom half of the image, you can crop out some of the cloak and diminish the appearance of bulk. Leave some of the bottom of the frame open to add some visual appeal to the composition.

STEP FIVE

Begin shading the cloak. Add enough detail to the cloak so it appears realistic. You want to capture both value and texture, so after shading, go back in with a soft, dull #2 pencil and add a little bit of linework to indicate the rough weave of Luke's homespun cloak.

STEP SIX

Luke's loose, flowing hair is intimidating, but as long you do an effective job depicting the interplay of light and shadow, you'll be fine. Don't worry about individual hairs until you're nearly finished. For now, draw sections of hair as objects lying on top of and around each other.

RESISTANCE

When depicting Luke's eyes, try to indicate the wisdom and experience he's obtained over the years without making him look old. As you work on the beard, focus on accurately depicting differences in value. Also make sure that the weave of his tabard is not as rough as his cloak. The robe is almost entirely white, so the value on the tabard can be very light.

The right side of Luke's hair is shadowed a bit more than the left, so make sure that's apparent. Depict the right side of the cloak in the same manner as the left, and as you finish the face, make sure you haven't overdone the wrinkles.

RESISTANCE

STEP
NINE

During the final polish, slightly boost the contrast and smooth out some of the cragginess in Luke's face. Add some individual, flyaway hairs and enhance the detail in his tabard. Hopefully, the finished portrait depicts Luke as older, wiser, and immeasurably sadder than he was in *A New Hope*.

About the Artist

Artist and author Russell Walks made his first *Star Wars* drawing—in ballpoint pen on the back of an envelope—on his way home from the movie theater on a rainy afternoon in 1977. It was a portrait of Luke Skywalker. Or it may have been Han Solo. Some areas around the chin looked sort of like Greedo. Honestly, it wasn't very good, but that didn't really matter because for the few minutes Russell was drawing, while his mom was fighting traffic and his sister was complaining about the rain, he was on the Death Star shooting at stormtroopers and doing his best to save a princess. In the years since that first drawing, Walks has created work based on science fiction and pop culture for some of the largest and most well-known companies in the world. He's also drawn Luke Skywalker about a thousand times. And still, every single time he puts pencil to paper and begins another *Star Wars* drawing, he feels the same sense of wonder and magic he felt on that rainy afternoon in 1977.